How to Draw the Life and Times of
Gerald R. Ford

Michael F. Plaut

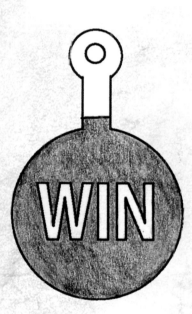

The Rosen Publishing Group's
PowerKids Press™
New York

For Caleigh, Elliot, and Harry

Published in 2006 by The Rosen Publishing Group, Inc.
29 East 21st Street, New York, NY 10010

First Edition

Editor: Daryl Heller
Layout Design: Greg Tucker
Photo Researcher: Nicole DiMella

Illustrations: All illustrations by Albert Hanner.
Photo Credits: pp. 4, 8, 10, 14 (bottom), 16, 18 (top), 22 Courtesy Gerald R. Ford Library; p. 7 © AP Photo; p.
9 Courtesy of Charles Parks Studio; p. 12 (top) Courtesy Corey Leiby/Antique Athlete; p. 12 (bottom) © AP
Photo/University of Michigan; p. 14 (top) Courtesy Naval Historical Center; p. 18 (bottom) LBJ Library photo by
Cecil Stoughton; p. 20 © Addison-Wesley Educational Publishers Inc.; p. 24 © Corbis Sygma; p. 26 (bottom) ©
AP Photo; p. 28 National Portrait Gallery, Smithsonian Institution/Art Resource, NY.

Library of Congress Cataloging-in-Publication Data

Plaut, Michael F.
How to draw the life and times of Gerald R. Ford / Michael F. Plaut.— 1st ed.
p. cm. — (A kid's guide to drawing the presidents of the United States of America) Includes index.
ISBN 1-4042-3014-9 (library binding)
1. Ford, Gerald R., 1913– —Juvenile literature. 2. Presidents—United States—Biography—Juvenile literature.
3. Drawing—Technique—Juvenile literature. I. Title. II. Series.
E866.P58 2006
973.925'092—dc22

2005020023

Printed in China

Contents

The Early Years

When President Richard Nixon resigned on August 9, 1974, because of his part in the Watergate affair, Vice President Gerald Rudolph Ford Jr. became president of the United States. At that time many Americans distrusted their government leaders. Ford's sincerity 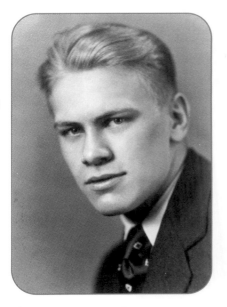 would help renew Americans' faith in the presidency.

Ford was born Leslie Lynch King Jr. in Omaha, Nebraska, on July 14, 1913. His parents were Dorothy Gardner and Leslie Lynch King. After fewer than two years of marriage, his parents divorced. His mother brought Leslie to live with her and her parents in Grand Rapids, Michigan.

In Michigan his mother met and married Gerald R. Ford, who raised Leslie and gave him his name. Gerald Sr.'s honesty and hard work in running his paint business earned him the respect of his community and served as an example for Gerald Jr. His parents expected Gerald and his three younger half brothers,

Tom, Dick, and Jim, to follow three rules, "Tell the truth, work hard, and come to dinner on time."

When he was 12 years old, Ford became a Boy Scout. The Boy Scouts of America is a youth group that helps build character in boys. Ford rose to the highest level in scouting in just three years when he became an Eagle Scout in November 1927.

You will need the following supplies to draw the life and times of Gerald R. Ford:

✓ A sketch pad ✓ An eraser ✓ A pencil ✓ A ruler

These are some of the shapes and drawing terms you need to know:

Horizontal Line	——	Squiggly Line	∿∿∿
Oval	⬭	Trapezoid	⏢
Rectangle	▭	Triangle	△
Shading	▰	Vertical Line	\|
Slanted Line	/	Wavy Line	∿

The Ford Presidency

When Gerald R. Ford became president in 1974, millions of Americans were out of work, and the prices of food, clothing, and gasoline were rising. The high prices meant Americans bought less. Businesses were not selling as much and therefore could not hire as many people. Americans also worried that they would not have enough gas or heating fuel. The 1973 fuel shortage began in part after some oil-producing nations reduced the amount of oil coming into the United States.

President Ford also faced problems overseas. The American troops that had been sent to fight in the Vietnam War had been brought home in 1973. The South Vietnamese, allies of the United States, were losing the war to the Communist North Vietnamese. Ford wanted to help the South Vietnamese with money and weapons. Congress refused. Ford was successful, however, in his 1974 talks with Leonid Brezhnev, the leader of the Soviet Union. The two men agreed to reduce the risk of a nuclear war.

A president will hold a press conference when he or she has important news to share with newspaper and TV reporters. On September 8, 1974, President Ford told reporters that he had decided to pardon, or officially forgive, President Nixon for any crimes he had committed.

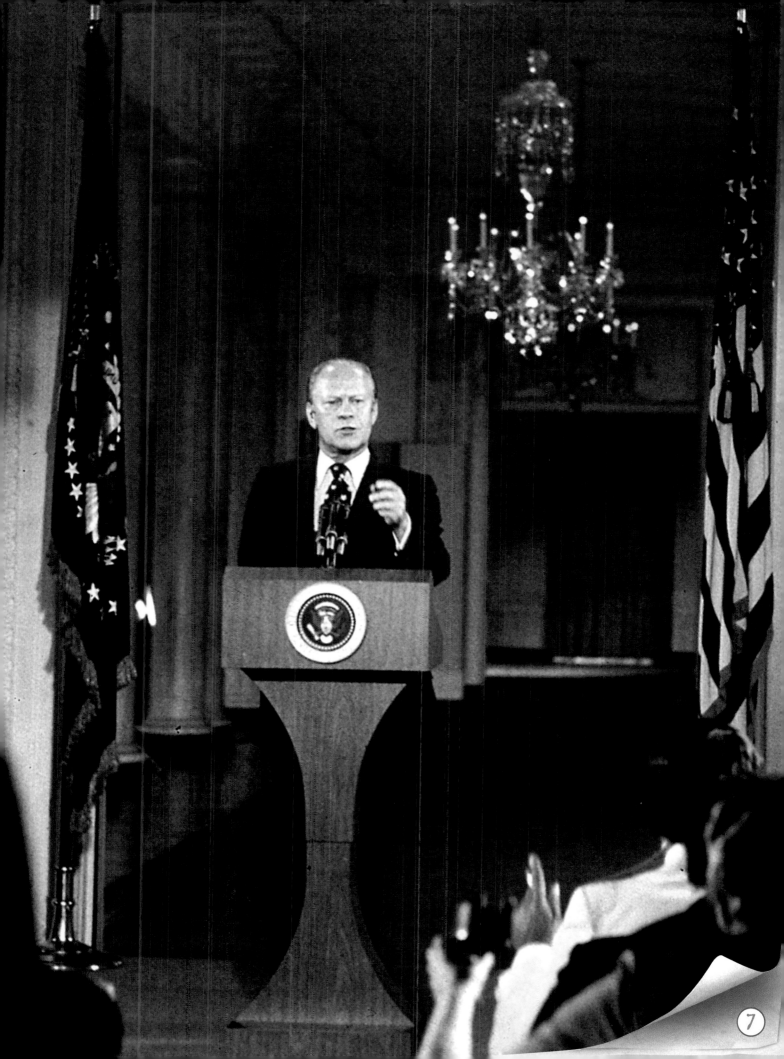

Gerald R. Ford's Michigan

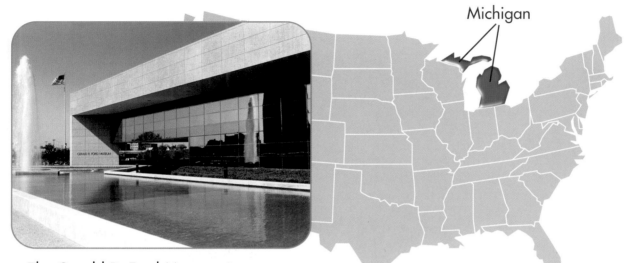

The Gerald R. Ford Museum is open year-round to visitors.

Map of the United States of America

Michigan is where Gerald R. Ford was raised and where he attended school. As a Michigan congressman, Ford spent many years representing the state in the U.S. Congress. Michigan has a number of places honoring President Ford. The Gerald R. Ford Library is in Ann Arbor, Michigan, where Ford attended college. The library collects and preserves records of Ford's public service, as well as other historical objects.

The Gerald R. Ford Museum is in Grand Rapids, Michigan, where Ford grew up. The museum presents U.S. history after World War II and the years of the Ford presidency. The museum also hosts exhibits and

special events. Exhibits have included a profile, or summary, of the life of President Theodore Roosevelt. There was also a model of the Oval Office, the room in the White House where the president works.

There are other places in Grand Rapids where President Ford is honored. The Boy Scouts council, or group, that serves the Grand Rapids area was renamed the Gerald R. Ford Council of the Boy Scouts of America. Outside the Grand Rapids Boy Scouts headquarters, there is a sculpture called *Gerald Ford as an Eagle Scout.*

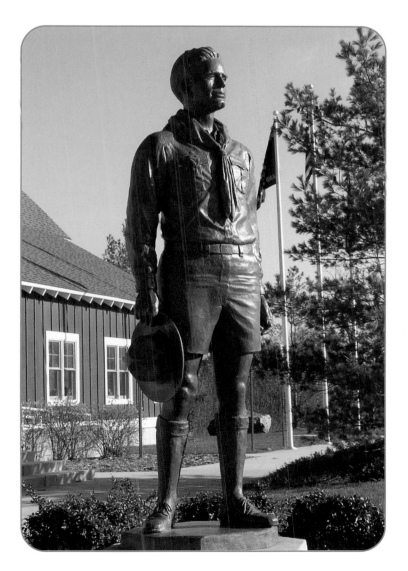

This bronze sculpture of Gerald Ford was created by the sculptor Charles Parks in 1997.

Growing Up in Grand Rapids, Michigan

Gerald R. Ford was born in Omaha, Nebraska, in the house shown at right. When he was still a baby, he and his mother moved to Grand Rapids, Michigan. As a 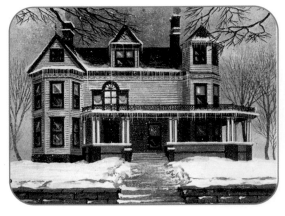 young boy, Ford loved to play sports, and he often came home from practice dirty and scraped.

As a teenager Ford served as a Boy Scout guide for visitors to Michigan's Fort Mackinac. This gave him the opportunity to meet and speak with many people. These skills would be useful to him as a politician.

In high school Ford's favorite classes were history and government. He received excellent grades and became a member of the National Honor Society. Ford was a high-school football star and was named to both the all-city and all-state teams. His position was center. The center starts a play by hiking the ball back, between his legs, to the quarterback. Ford also played basketball and ran track. To earn extra money while in high school, Ford worked at several part-time jobs.

1

On the facing page is the house in Omaha, Nebraska, where Gerald Ford was born. To begin drawing the house, make a horizontal rectangle. This will be your guide.

2

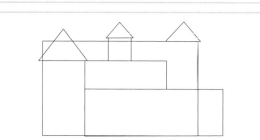

Draw two rectangles and one square inside the rectangle from step 1 as shown. Notice how the larger rectangle crosses over your guide rectangle. Add three triangles.

3

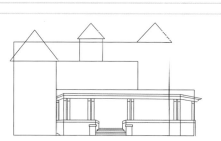

Draw the steps. Add the walls, columns, and roof for the porch using straight and slanted lines.

4

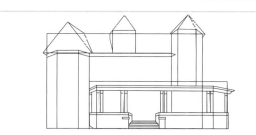

The house is divided and drawn into three sections. Add more vertical, horizontal, and slanted lines to the left side and the right side of the house. Add more lines to the roof.

5

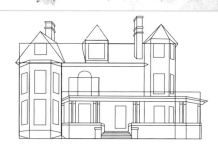

Add lines to the bottom of the house on the left. Begin drawing the windows, front door, and chimneys as shown. The large window on the second floor has a half circle over it.

6

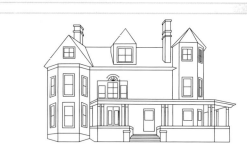

Erase extra lines. Add a rectangular frame inside each window. Add lines to the windows as shown. Draw a window inside the front door. Add lines to the side of the house.

7

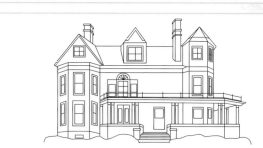

Add lines to the triangles. Add lines to the top part of the house. Draw a railing above the porch. At the base of the house draw a rectangular window and a wavy line for snow.

8

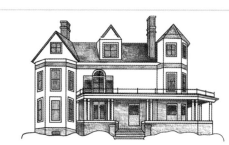

Shade your drawing of the house. The roof, the chimneys, and some of the windows are shaded dark. The other areas of the house can be shaded lighter. Some parts are not shaded.

Ford Attends the University of Michigan and Yale University

After graduating from high school in 1931, Gerald R. Ford wanted to continue school and play football at the University of Michigan. However, the Depression had hurt his stepfather's business, and Ford did not have enough money to enroll. Ford's high-school principal arranged for one year's fees, and Ford was able to enter college. He worked in the summer and during college to pay his other expenses.

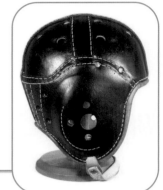

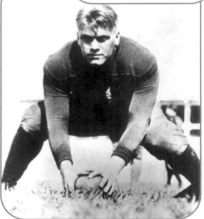

Ford was a star center for the University of Michigan Wolverines football team. Both the Detroit Lions and the Green Bay Packers asked him to play for their teams. Ford's dream, however, was to become a lawyer. To pay for law school, Ford took a job as the boxing coach and an assistant football coach at Connecticut's Yale University in 1935. He began taking law courses at Yale Law School several years later in the spring of 1938. Ford did well in his law studies and graduated from Yale Law School in 1941.

1

Football helmets help protect players' heads. Page 12 shows a 1930s leather football helmet. Ford may have worn such a helmet as a college football player. Begin your drawing of a helmet with a guide rectangle.

2

Inside the rectangle draw the curved shape as shown. Notice how the top half of the shape is wider than the bottom half.

3

Inside the curved shape draw the outline of the helmet as shown. Inside this outline draw a second line. Notice how there is only one line, though, at the back of the helmet.

4

Erase the guides from step 1 and step 2. Draw the dotted lines for the stitching on the helmet. Look closely at the drawing and the photograph before you begin.

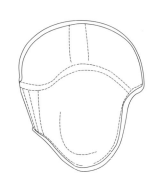

5

Draw circles and ovals inside the helmet. There are six ovals at the top, two circles in the middle, and four ovals and four circles at the bottom of the helmet.

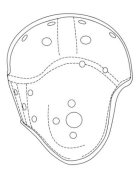

6

At the bottom of the helmet draw a chin strap. The chin strap is created using curved lines and a small oval.

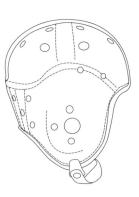

7

Inside the circles and ovals on the helmet add the curved lines as shown.

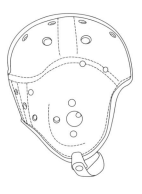

8

Shade your helmet. Shade the area that is inside the curved lines you made in the last step the darkest. Shade the rest of the helmet and the chin strap lighter.

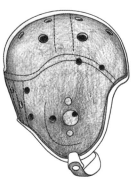

Young Lawyer and Naval Officer

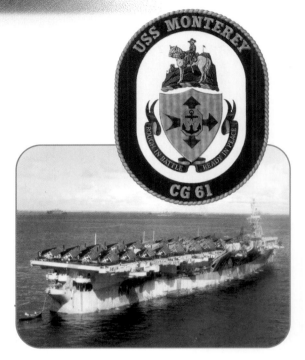

In 1941, Gerald R. Ford and a college friend formed a successful law firm in Grand Rapids. On December 7, however, Japanese airplanes attacked Pearl Harbor, a naval base in Hawaii, and the United States entered World War II. Ford requested naval duty. He served aboard the USS *Monterey*, an aircraft carrier. That is a ship on which planes can take off and land. The ship and its crest are shown above.

As the ship's gunnery officer, Ford helped direct the firing of weapons. In December 1944, the ship was being tossed by a typhoon, a powerful storm, in the South Pacific. Ford went on deck to see if the ship was harmed and was nearly thrown overboard. Three men died in the storm. The ship was in need of repair, and the planes were lost or harmed.

Ford served the remainder of the war in Illinois. The war ended in 1945. Ford then returned to Grand Rapids and worked at a well-known law firm.

1

On the facing page is the official crest of the USS *Monterey*. To begin drawing the shield that is at the center of the crest draw a rectangle. This will be your guide.

2

Inside the rectangle draw the curved and pointed outline of the shield. Draw two vertical lines down the center of the shield. Next add two horizontal lines across the middle of the shield as shown.

3

Using your guidelines draw two arrows as shown. The vertical arrow has an arrowhead at either end. The horizontal arrow has a shape on the left side and an arrowhead on the right side.

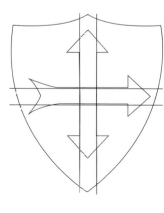

4

Erase the guidelines. At the center of the arrows draw a rectangle with rounded edges.

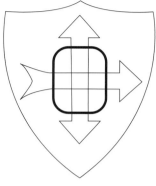

5

Erase the lines from the overlapping arrows. Draw an anchor like the one shown inside the box. Notice the details inside the star in the middle of the anchor.

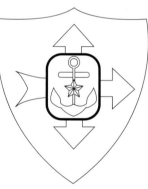

6

Finish by shading in your shield. The arrows, anchor, and star might be shaded darker than the rest of the shield.

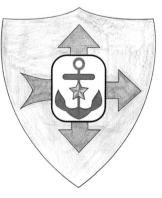

Betty Ford and the Ford Family

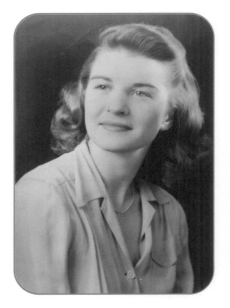

After the war Gerald R. Ford met and fell in love with Elizabeth Anne "Betty" Bloomer, who worked as a department store fashion coordinator, or planner, in Grand Rapids. Ford proposed marriage to Betty in February 1948. In June of that year, Ford announced that he would run for U.S. Congress as the representative of the district serving Grand Rapids. On October 15, 1948, the couple married. In November Ford was elected to Congress. The Fords moved to Washington, D.C., where they would raise four children, Mike, Jack, Steve, and Susan.

Later when Betty Ford became the First Lady, she helped many people by raising their awareness about cancer. Betty had that illness while her husband was president. Throughout their marriage Ford would always talk with Betty before making any important career decisions. When Ford became president in 1974, he said, "I am indebted to no man, and only to one woman—my dear wife."

1

The photograph of Betty Ford on the facing page was taken when she was 18 years old. To begin drawing Betty Ford draw a rectangle.

2

Draw an oval guide for her head. Add a curved line down its middle. Add three circle guides for her eyes and nose. Add a curved line for her mouth. Use slanted lines as guides for her neck and shoulders.

3

Use wavy and curving lines to draw the outlines of her face, neck, hair, and shoulders. Add curving lines to begin creating her collar.

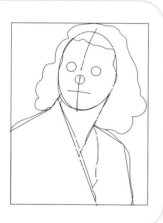

4

Add details inside her eye guides. Draw her eyebrows, her mouth, and the bottom of her nose. Draw the edges of her cheeks. Use curving lines for part of her ear on the right. Use one curved line for her necklace.

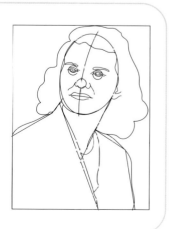

5

Erase extra lines. Use squiggly lines of different lengths to draw the waves in her hair.

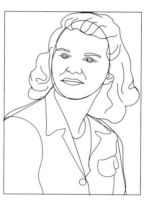

6

Draw the rest of her collar and shirt pocket as shown. Draw the sleeves of her shirt. Add a button to her shirt.

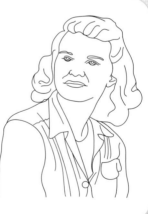

7

Erase the remaining guides you drew in step 1 and step 2. Draw the folds in the front of the shirt using curving lines. Draw a squiggly line at her shoulder on the left.

8

Finish by shading your drawing of Betty Ford. Her hair, eyes, shirt, and mouth are shaded darker than the other areas of the drawing.

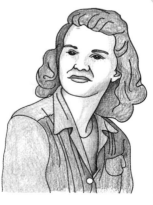

Congressman Gerald Ford

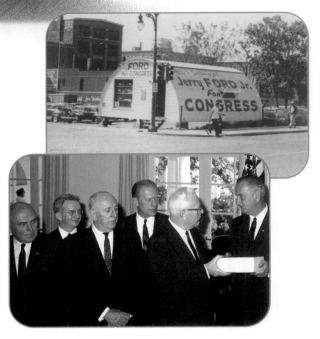

Gerald R. Ford's enthusiastic campaigning in Michigan, as shown in the top image, led him to victory in his first congressional race in 1948. Ford, a Republican, represented his Grand Rapids district for 25 years. He served on the House Appropriations Committee, where Ford helped decide how the government spent its money. Later he served on the defense subcommittee, where Ford helped decide where the military should direct their funds. Congressman Ford supported the United States' part in the Korean War and the Vietnam War. He was in favor of protecting the nation by increasing American armed forces and weapons.

President John F. Kennedy was killed in 1963. The new president, Lyndon Johnson, asked Ford to serve on the Warren Commission. That was a group that looked into the killing. The commission, shown above, reported to Johnson that Kennedy's killer had acted alone. In 1965, Ford became House minority leader, the Republicans' leader in Congress.

1

A Quonset hut, which is shown on the facing page, is a quickly built shelter. This Quonset hut was used to publicize Gerald Ford's 1948 congressional campaign. To begin creating the Quonset hut draw a rectangular guide.

2

Draw an outline of the basic shape of the Quonset hut. Notice that there is a small bump in the outline on the upper right side.

3

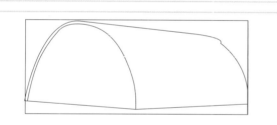

Draw an arch using a curved line inside the shape you made in step 2. This will be the outline for the front of the building.

4

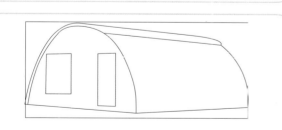

Add a window and a door to the front of the hut using rectangles. Along the hut's top add a long sloping line. The line ends on the right, just under the small bump you made in step 2.

5

Draw the lines inside the window and door as shown. Add an open window to the side of the building. Look carefully before you begin. The side window is drawn using curved and straight lines.

6

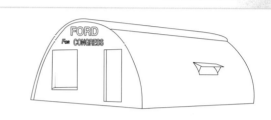

Erase the rectangular guide from step 1. On the front of the building write the words "FORD For CONGRESS."

7

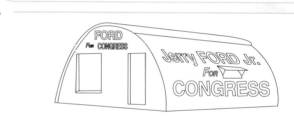

On the side of the building write the words "Jerry FORD Jr. FOR CONGRESS."

8

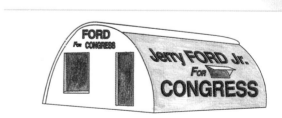

Finish by shading the side, the door, and the window of the hut. You might shade the words, too.

Vietnam War and Watergate

After the North Vietnamese army attacked a U.S. ship in 1964, the United States began bombing North Vietnam. The United States sent U.S. troops to protect South Vietnam. Congressman Gerald R. Ford still faulted President Johnson for not being more forceful in attacking the enemy. In 1968, Richard Nixon was elected president. Ford would support Nixon's decision to bomb the North Vietnamese. Bombing did not end the fighting and Americans' support for the war lessened. In January 1973, an agreement was signed that ended the United States' participation in the war.

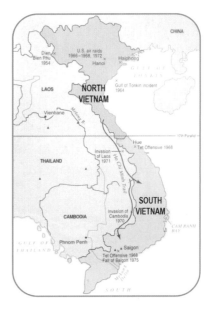

The early 1970s brought other worries for Nixon. During the 1972 presidential campaign, which ended in his reelection, five men were caught breaking into the Democratic headquarters at the Watergate Hotel. The break-in was traced to Nixon's supporters. Judges then ordered Nixon to hand over his tape recordings. They proved that he and members of his staff had tried to cover up the Watergate break-in.

1

On the facing page is a map of North Vietnam and South Vietnam. Make a rectangle to begin drawing North Vietnam and South Vietnam.

2

Inside the rectangle draw a rough outline of these two countries. We will separate them in a later step. Use the drawing and the map on the opposite page as a guide to help you create this shape.

3

Inside the shape you made in step 2, draw another, more detailed, outline of North Vietnam and South Vietnam. This outline is created using wavy lines.

4

Erase extra lines. Add a squiggly shape inside the top part of your drawing. You have just drawn North Vietnam.

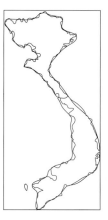

5

Add squiggly lines for the outline of South Vietnam. Draw an island off the coast of South Vietnam. This island is Phu Quoc, which is sometimes called Emerald Island. An emerald is a green stone.

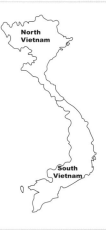

6

Erase the rectangular guide from step 1. Add the words North Vietnam to the top half of your map. Add the words South Vietnam to the bottom half.

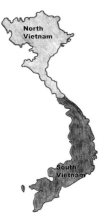

7

Finish by shading your map of North Vietnam and South Vietnam. Shade South Vietnam slightly darker than North Vietnam.

From Vice President to President

In 1973, Vice President Spiro Agnew resigned after being accused of having accepted bribes when he was governor of Maryland. President Nixon selected Congressman Gerald Ford to be his vice president. Congress confirmed Ford and he took office on

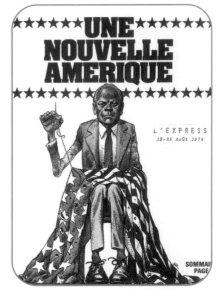

December 6, 1973. By 1974, there was no doubt that President Nixon had acted improperly during the Watergate scandal. On August 9, 1974, President Nixon became the first president to resign. Ford was sworn in the same day and became the first person to serve as president without being elected.

President Ford decided to pardon former president Nixon. Then he could attend to issues such as the troubled economy. The image above plays on Ford's role in mending America. The pardon upset many Americans, however. They thought Nixon should be tried for a crime. On December 19, Nelson A. Rockefeller was sworn in as Ford's vice president.

1 The cartoon of President Gerald Ford on the facing page appeared in an August 1974 issue of *L'Express*, which is a French magazine. To begin your cartoon of President Ford draw a square.

2 Draw an oval for his head guide. Use straight and curving lines to make the shapes of his body, left arm, legs, and shoes. Draw the sides of the American flag that will be placed over his lap.

3 Add lines for the top of the flag, as well as for the folds inside the flag, which is draped over Ford's lap. Look at the drawing and the cartoon on the opposite page to help you.

4 Using the guides you drew in step 2, add details to his legs, ankles, and shoes. Use small loopy shapes to make his shoelaces. Draw two curved lines across the top of his shoes.

5 Draw his face, ears, neck, and hair. Draw lines for his jacket. Draw his shoulders, his sleeves, and the left side of his body. Draw his hand, his wrist, the needle he holds, and the thread connecting the needle to the flag.

6 Erase extra lines. Draw his collar, tie, and lapels, or folded edges of his jacket. Finish the arm on the right. Draw the tiny line where he bends his other arm. Around his legs and feet, add lines for the chair.

7 Add stripes and stars to the American flag across Ford's lap. The starred area is at the center and on the left. The striped area is on the right.

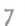

8 Finish by shading your cartoon of President Ford. Notice how some parts are shaded darker than others and how some parts, such as his shirt, are not shaded at all.

The Evacuation of Vietnam and the Arms Talks

By April 1975, North Vietnam had almost completed its attacks on South Vietnam. It became necessary to evacuate, or remove, the Americans 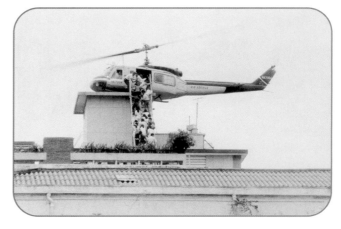 who had remained in South Vietnam's capital, Saigon. President Ford ordered thousands of Americans, as well as many South Vietnamese children, airlifted to safety. A few weeks later, Communist forces from the neighboring country of Cambodia captured the U.S. ship *Mayaguez* and its crew. President Ford sent U.S. Marines to rescue the crew. Both the crew and the ship were recovered.

President Ford worked hard to improve the United States' relations with other countries. The United States sought a détente, or meetings to ease strain, with the Soviet Union. In July 1975, President Ford and Secretary of State Henry Kissinger met with representatives from the Soviet Union and other nations in Helsinki, Finland. These talks led to an agreement that included guidelines for protecting human rights.

1

[blank rectangle]

After Saigon was taken over by the North Vietnamese, escaping on foot was not safe. Helicopters were used to airlift, or carry away, people to safety. Begin drawing the helicopter by making a long rectangle.

2

Draw a rough outline of the main body of the helicopter. Next draw an outline for the propeller that is on top of the aircraft.

3

Around your guides draw the shape of the helicopter. Draw the outline of the propeller. Notice how the piece that joins the propeller to the body of the aircraft is made with squiggly lines.

4

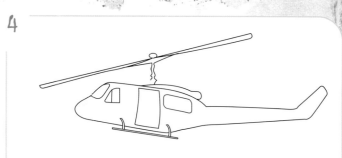

Erase the guides you made in step 1 and in step 2. Draw three windows as shown. Add a door. Notice how the top of the door is narrower than the bottom. Draw a railing below the door. The railing has three parts.

5

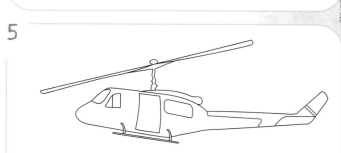

Add details to the tail, or back, of the helicopter as shown. You are almost finished. You have only one more step.

6

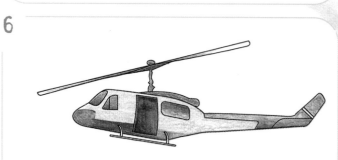

Finish by shading your helicopter. The bottom and tail of the helicopter are dark. The door, windows, and parts of the propeller's blades are dark, too.

Fighting Inflation and the Recession

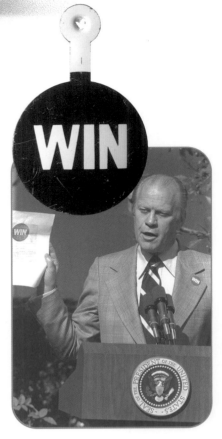

The U.S. economy was in poor shape when President Gerald R. Ford took office. The economy continued to falter. The prices of products such as food, clothing, and gasoline got more expensive. That is a condition known as inflation. On October 8, 1974, Ford presented the Whip Inflation Now (WIN) program. Ford asked Americans to fight inflation by curbing their spending and saving energy.

Unfortunately, the program never worked. By early 1975, the U.S. economy was in a recession. That is a period of slow business activity and an increase in the number of people who are out of work. Ford and Congress disagreed on how best to address these problems. Ford believed that the government should not spend more money than it was able to collect from taxes and other sources of money. Ford vetoed bills from Congress that he felt would cost the government too much money. The U.S. economy would not fully come out of the recession until the 1980s.

1

A Whip Inflation Now, or WIN, button is shown on page 26. The other picture shows Ford presenting the Whip Inflation Now program. Start your drawing of a WIN button by drawing a rectangle.

2

Draw a large circle at the bottom of the rectangle. Draw a small circle at the top of the rectangle.

3

Draw two vertical lines connecting the two circles. Erase the parts of the circles that are between the two vertical lines.

4

Erase the rectangular guide you made in step 1.

5

Add a small circle inside the circle area at the top to make the button fastener. Draw a horizontal line in the section between the two circles. This is where the button fastener bends.

6

In the bottom part of the button write the word "WIN" in block letters.

7

Finish by shading your WIN button. Leave the word "WIN" white. Leave the top part of the button white, too.

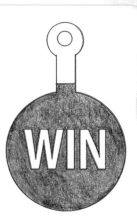

The Presidential Election of 1976 and Retirement

President Gerald R. Ford sought reelection in 1976. By 1976, the American economy had improved somewhat. Still many voters thought it was time for a change. Many Americans felt that Ford should not have pardoned President Nixon. In a close presidential election, 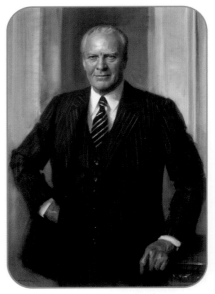 Americans elected Georgia's Democratic governor, James Earl "Jimmy" Carter.

Since leaving office President Ford has spoken on and written about many public issues, including affirmative action. In 1982, Betty Ford helped found the Betty Ford Center, a treatment center for people trying to overcome dependence on drugs. The Fords have remained active supporters of the center. In 1999, they received the Congressional Gold Medal for public service and contributions to humanity. Perhaps Ford will be best remembered by the words of President Carter, who said, "For myself and for our Nation, I want to thank my predecessor for all he has done to heal our land."

1

The artist Everett Raymond Kinstler painted the 1987 picture of President Ford shown on the facing page. To begin drawing President Ford draw a vertical rectangle.

2

Draw an oval for his head. Add an outline for his neck, body, and arms. Draw the top edges of his vest. Draw the outline of the bottom of his jacket on the left. Add triangles for the openings made by his bent arms.

3

Draw the outline of his face and add more lines for his neck. Draw his hairline. Draw circle guides for his eyes and nose. Add a line for his mouth, his shirt collar, and a tie.

4

Draw his eyes, eyebrows, nose, and the lines around his mouth. Add lines to his ears. Outline the shape of his body. Add lines for his coat and shirtsleeves. Draw his hands. One hand is partly hidden.

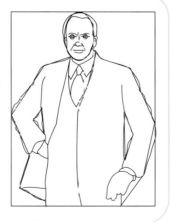

5

Erase any extra lines as well as the guides you made in steps 1 and 2. Draw the lapels on his jacket. Draw the bottom of his vest and add buttons. Add folds to his jacket sleeves.

6

Draw the curved lines under his eyes. Draw the slanted lines on his striped tie.

7

Add fingers to the hand on the right. Draw slanted lines as shown for his desk. Most of these lines are beside the hand that rests on the desk. However, one line is just to the right of his sleeve.

8

Finish by shading your drawing of President Ford. His desk, his jacket, and his striped tie are the darkest areas of the drawing.

Timeline

1913 Leslie Lynch King Jr. is born in Omaha, Nebraska, on July 14. He later changes his name to Gerald Rudolph Ford Jr.

1931 Ford enters the University of Michigan.

1941 Ford graduates from Yale Law School.

1942–1946 Ford serves in the U.S. Navy.

1948 Ford marries Elizabeth "Betty" Bloomer on October 15.
On November 2, Ford is elected to Congress for the first of 13 terms. He serves the fifth District of Michigan in the U.S. House of Representatives.

1964 The Warren Commission issues its report on the Kennedy killing on September 24.

1965–1973 Ford serves as House minority leader in Congress.

1973 Gerald R. Ford is sworn in as U.S. vice president on December 6.

1974 On August 9, Nixon resigns as president. Gerald R. Ford is sworn in as the thirty-eighth U.S. president later the same day.

1975 Communist forces capture Saigon in South Vietnam, on April 30.

1981 The Gerald R. Ford Library and Museum opens in Michigan in April.

1999 On August 11, President Bill Clinton gives former president Ford the Presidential Medal of Freedom for his work to heal the nation after the Watergate scandal. That same year Gerald Ford and Betty Ford are given a Congressional Gold Medal for their public service and aid to humanity.

Glossary

affirmative action (uh-FER-muh-tiv AK-shun) Efforts to correct past wrongs by granting economic or educational advantages.

allies (A-lyz) Countries that are friendly and that help each other in times of crisis.

appropriations (uh-proh-pree-AY-shunz) Money that has been set aside for a purpose.

bribes (BRYBZ) Money or favors given in return for something else.

committee (kuh-MIH-tee) A group of people directed to oversee or to consider a matter.

Communist (KOM-yuh-nist) Belonging to a system in which all the land, houses, and factories belong to the government and are shared by everyone.

Depression (dih-PREH-shun) A period of American history during the late 1920s and early 1930s. Banks and businesses lost money and there were few jobs.

House minority leader (HOWS my-NOR-ih-tee LEE-der) The leader of the political party in the House of Representatives that has fewer members.

Korean War (kuh-REE-un WOR) The war fought by North Korea against South Korea from 1950 to 1953.

lawyer (LOY-er) One who gives advice about the law and who speaks for people in court.

nuclear (NOO-klee-ur) Having to do with the power created by splitting atoms, the smallest bits of matter.

pardon (PAR-dun) To excuse someone who did something wrong.

predecessor (PREH-deh-seh-ser) Someone who comes before.

resigned (rih-ZYND) Stepped down from a position.

Soviet Union (SOH-vee-et YOON-yun) A former nation that reached from eastern Europe and across Asia to the Pacific Ocean.

vetoed (VEE-tohd) Did not allow laws proposed by another branch of government to pass.

Vietnam War (vee-it-NOM WOR) A war fought between South Vietnam and North Vietnam in the late 1960s through the mid-1970s, in which America took part.

Watergate scandal (WAH-tur-gayt SKAN-dul) A crime committed by officials from the Republican Party who broke into the Democratic headquarters to steal secrets that would help President Nixon be reelected.

World War II (WURLD WOR TOO) A war fought by the United States, Great Britain, France, and the Soviet Union against Germany, Japan, and Italy from 1939 to 1945.

Index

Web Sites

Due to the changing nature of Internet links, PowerKids Press has developed an online list of Web sites related to the subject of this book. This site is updated regularly. Please use this link to access the list:
www.powerkidslinks.com/kgdpusa/ford/